i colour book
ABSTRACT DESIGNS

Designs by **Maisonette**

BATSFORD

| Marble | Paisley | Numeric | Homage to Pollock | Sunburst | Camouflage |

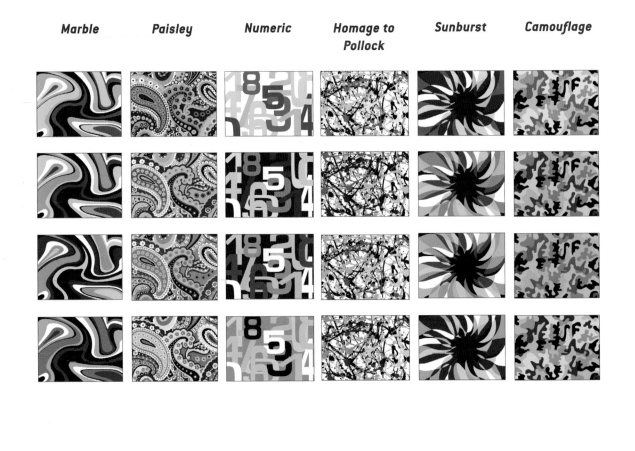

Introduction

Colour in these 24 cards and let your creativity run free! Leading interior designers Maisonette have provided 6 different abstract designs in 24 cards to colour with crayons, felt tips, pencils or even paint. You can colour in psychedelic colours, in tasteful tones, in all shades of orange, just as long as you add your own splash of creativity to make the designs come alive. For inspiration, a selection of possible colour combinations are provided.

All the cards are detachable, so you can pull them out and frame them or send them to a friend. Alternatively, keep them in this handy book as a great reference for colour combinations. The same design is provided four times, sometimes with slight variations, but with the addition of different colours, each card can look dramatically different from another.

The designs range from retro swirls and sunbursts through a modern camouflage to a do-it-yourself Jackson Pollock.

Choosing colours

Choosing colours is often an instinctive thing, but if you want to be more deliberate in your choices, try asking yourself some of these questions:

- Blue? What kind of blue? Remember, whatever colour you choose, you can go for a bright, a pale or a pure version or combine 'hues' of the same colour.

- Combine two colours? Or three or four? Or limit the palette for a more coherent finished piece?

- If more than one colour, which one should dominate? Experiment with your choices.

- Background colour? Keep it white, dark or go for another colour?

- What would happen if I used colour very sparingly?

- What would happen if I flooded the piece with colour?

First published in the United Kingdom in 2006 by

Batsford
151 Freston Road
London
W10 6TH

An imprint of Anova Books Company Ltd

ISBN 0 7134 9032 2
ISBN 9780713490329

A CIP catalogue record for this book is available from the British Library.

10 9 8 7 6 5 4 3 2 1

Reproduction by Mission Productions Ltd, Hong Kong
Printed by WKT Co Ltd, China

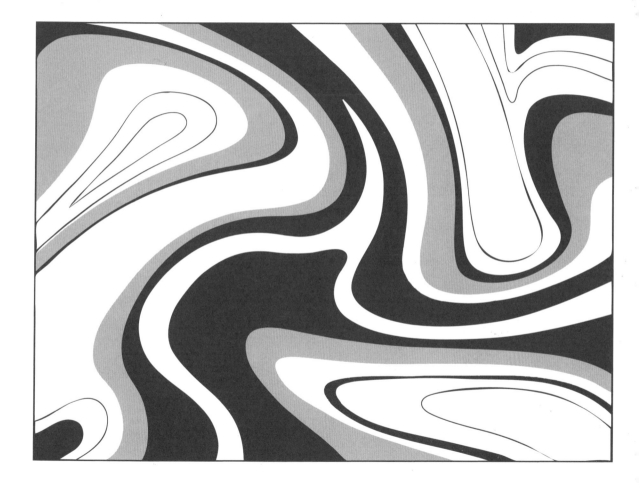

Marble by Maisonette

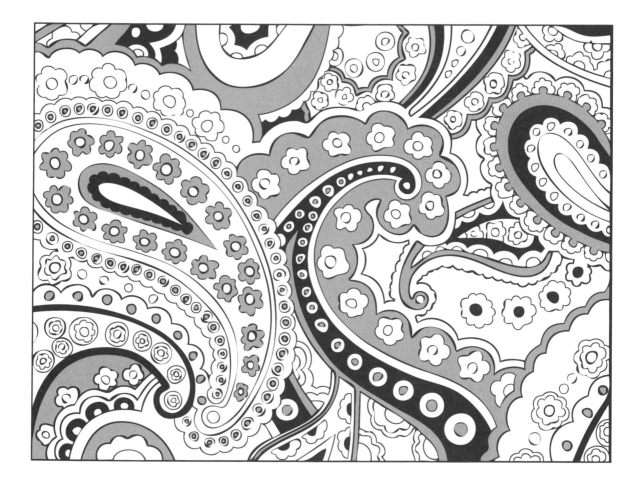

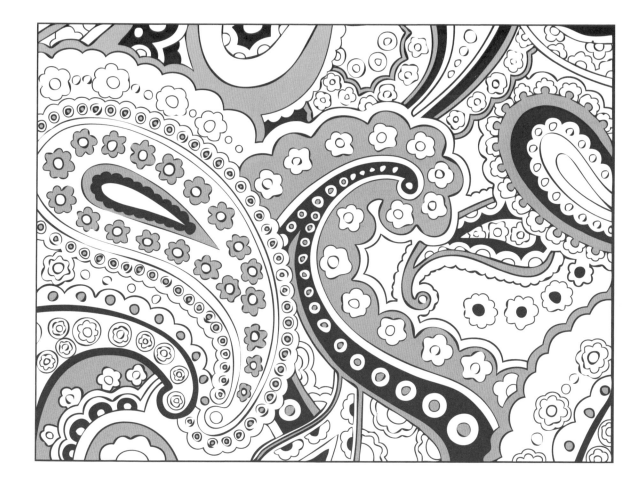

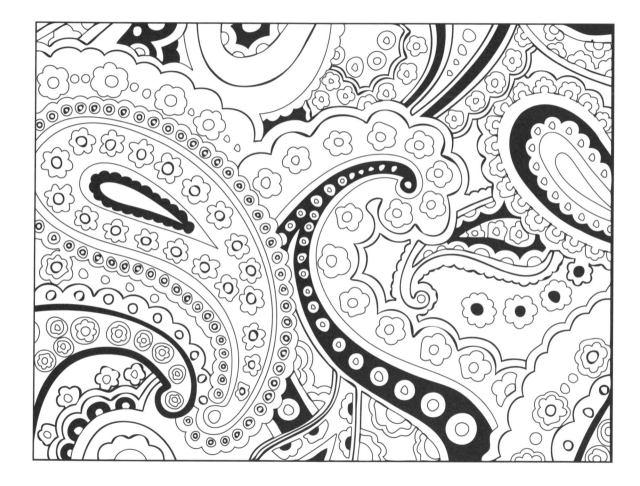

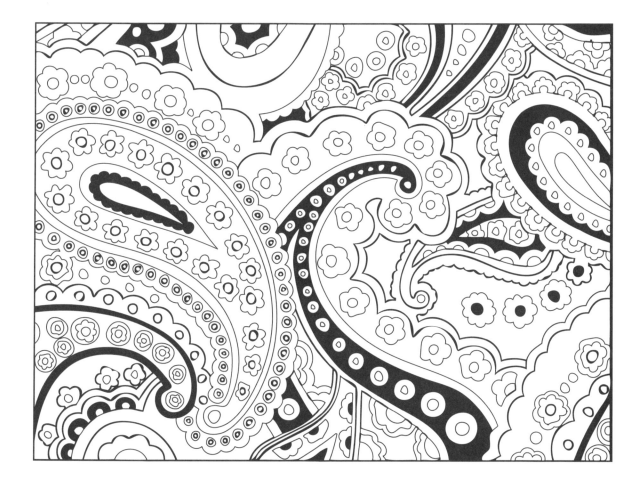

Paisley by Maisonette

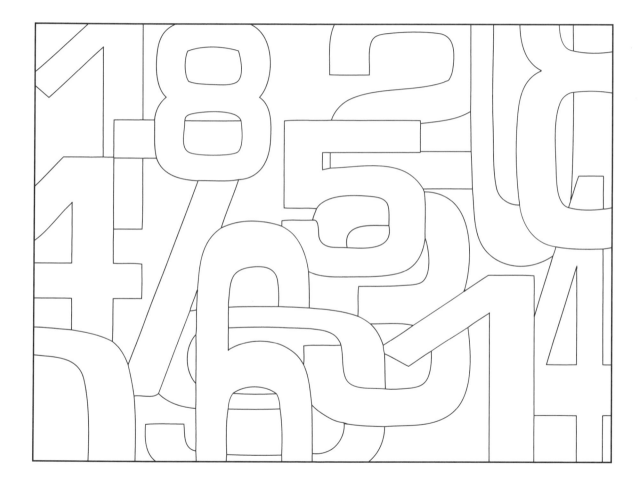

Numeric by Maisonette

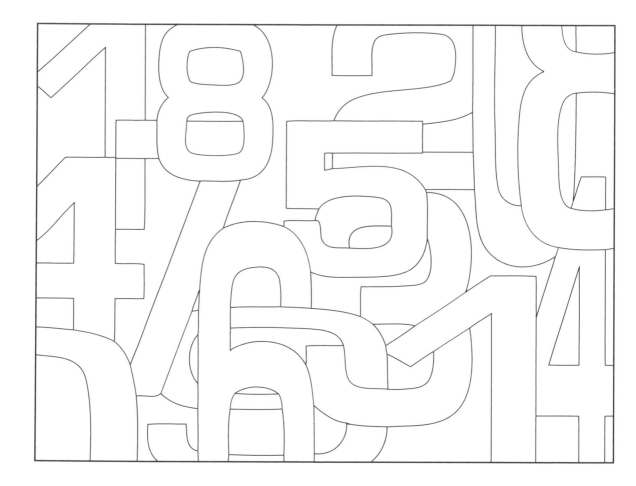

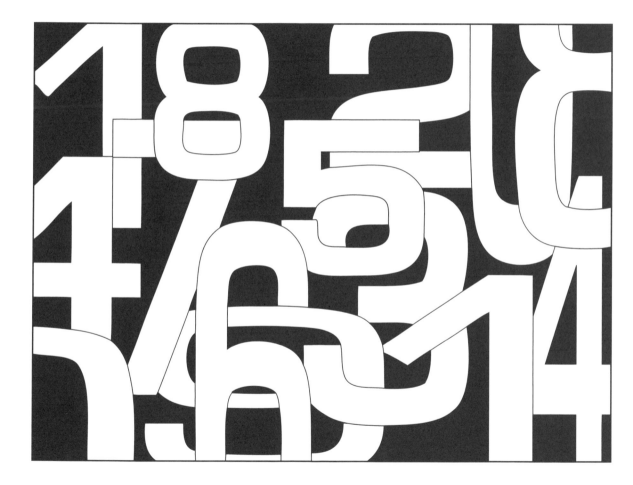

Numeric by Maisonette

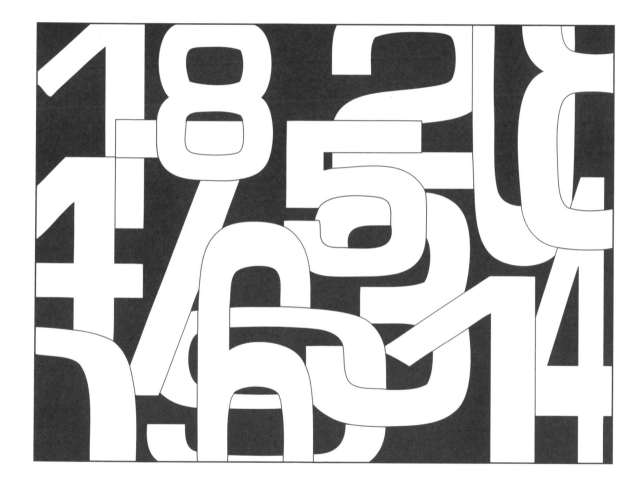

Numeric by Maisonette

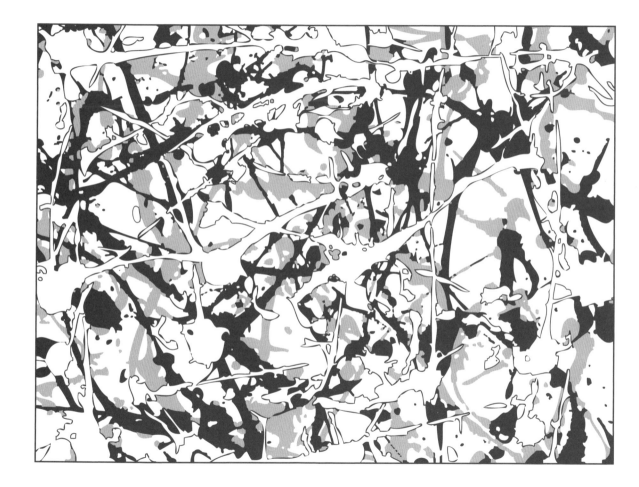

Homage to Pollock by Maisonette

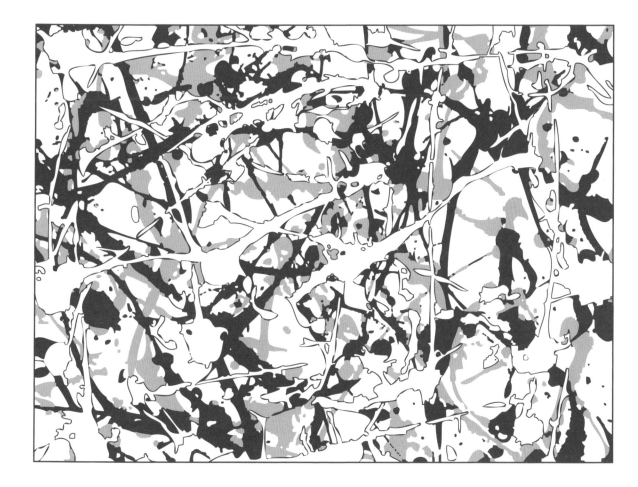

Homage to Pollock by Maisonette

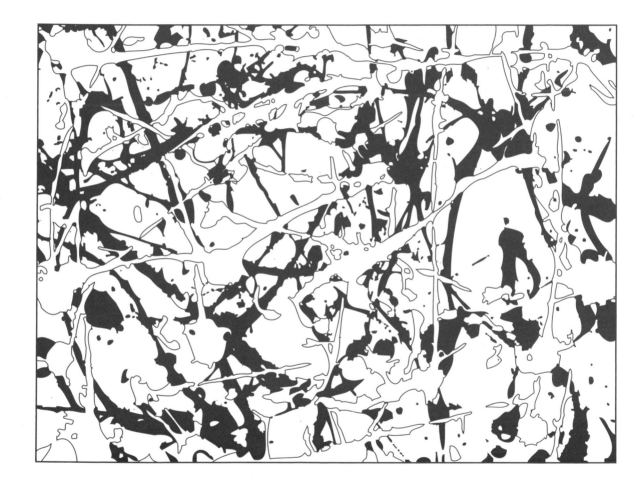

Homage to Pollock by Maisonette

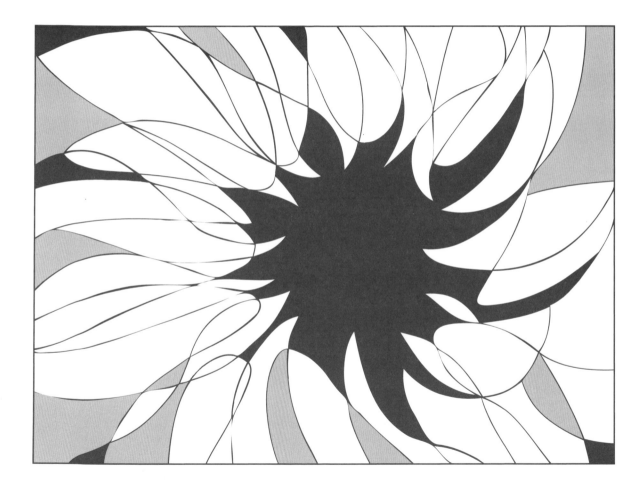

Sunburst by Maisonette

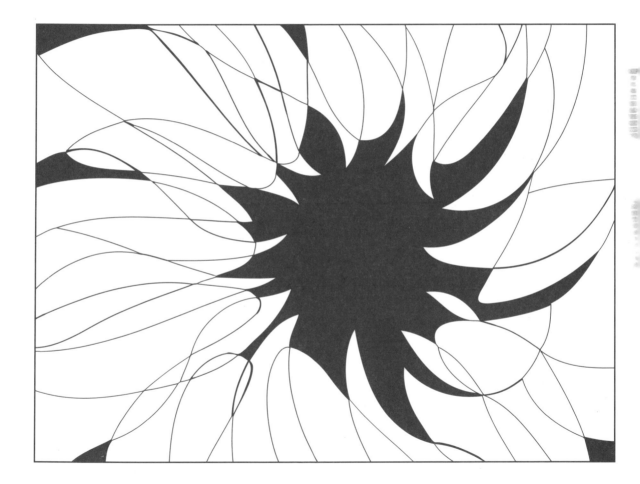

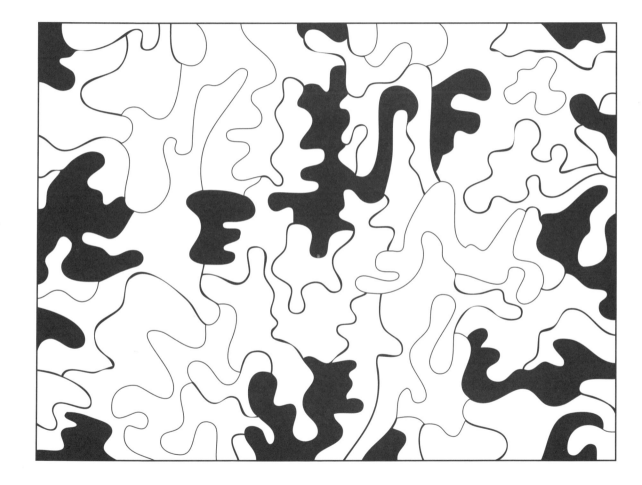

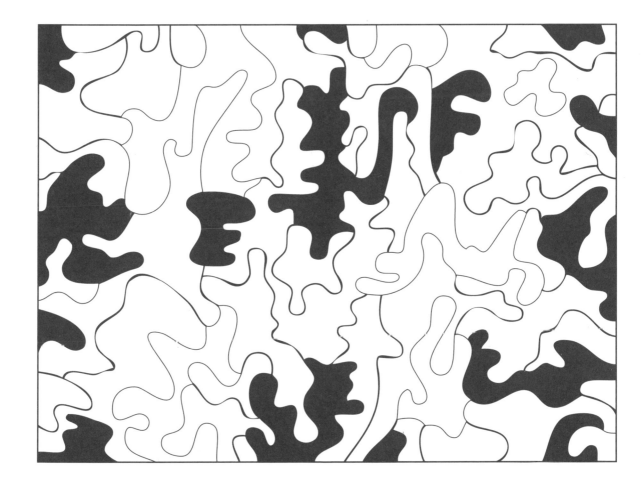

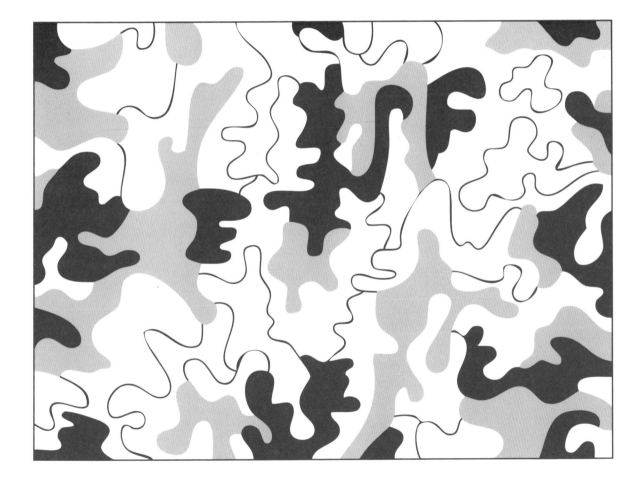